水盡雲起
RISING ABOVE

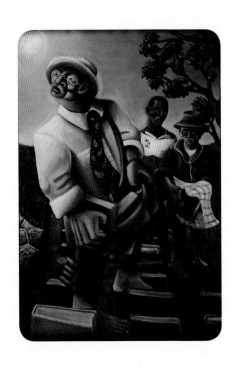

水盡雲起

RISING ABOVE

THE KINSEY AFRICAN AMERICAN
ART AND HISTORY COLLECTION

金賽收藏之非洲裔美國人的藝術及歷史

香港大學美術博物館
University Museum and Art Gallery
The University of Hong Kong

RISING ABOVE
THE KINSEY AFRICAN AMERICAN ART AND HISTORY COLLECTION
水盡雲起：金賽收藏之非洲裔美國人的藝術及歷史

CURATOR 策展人
DR FLORIAN KNOTHE 羅諾德博士

PUBLISHER 出版
CHRISTOPHER MATTISON 馬德松
UNIVERSITY MUSEUM AND ART GALLERY,
THE UNIVERSITY OF HONG KONG
香港大學美術博物館

CHINESE TRANSLATION 中文翻譯
EDWARD ZHOU 周政
ELENA CHEUNG 張寶儀

Produced in collaboration with KBK Enterprises, Inc. and the
Bernard and Shirley Kinsey Foundation for Arts & Education

EDITION 版次
December 2016
二零一六年十二月
© University Museum and Art Gallery,
The University of Hong Kong, 2016

ISBN 國際標準書號
978-988-19024-2-9

UNIVERSITY MUSEUM AND ART GALLERY,
THE UNIVERSITY OF HONG KONG
90 Bonham Road, Hong Kong
香港大學美術博物館
香港般咸道九十號

CO-ORGANISED BY 聯合主辦：

香港大學美術博物館
University Museum and Art Gallery
The University of Hong Kong

Faculty of Arts
THE UNIVERSITY OF HONG KONG

CONTENTS
目次

FOREWORD
前言

DR FLORIAN KNOTHE

DIRECTOR,
UNIVERSITY MUSEUM
AND ART GALLERY,
THE UNIVERSITY OF
HONG KONG

The University Museum and Art Gallery and the Faculty of Arts, The University of Hong Kong, are delighted to work with The Kinsey African American Art and History Collection to bring the first ever exhibition of African American history and culture to Asia. *Rising Above* highlights the artistic and social achievements of this long-established community and its contributions to mankind.

The fascination with this unique collection is multi-layered. The Kinseys have assembled and curated historic documents and artworks that detail the important contributions made by African Americans to the historic, economic and cultural development of the United States. The documentary value of The Kinsey Collection encompasses 400 years of history and portrays the unparalleled achievements of a people that have succeeded—often against great odds—to create its own identity within the American Dream, an economic and social triumph understood and celebrated the world over.

This rising above adversity is not a localised historic phenomenon, but one as much known in Asia as in America. The documents and artefacts shown in our exhibition—the very first display of The Kinsey Collection outside the U.S.—pertains to African emigrants and their life-stories, but, beyond a specific people, they speak for the social engagement and success, inclusion and exclusion, as well as the massive contribution of a minority group in our increasingly globalised world. In both East and West, minorities deserve recognition for their accomplishments and the requisite political freedoms to embrace and develop their own cultures.

HKU is proud to display and teach this topic, and is thankful for the opportunity to collaborate with the Kinseys to present documents as old as a sixteenth-century baptismal record in order to highlight the celebrated history of a people that stands as an ideal for so many others that persist and thrive among us—a global topic well understood in Hong Kong.

香港大學美術博物館及香港大學文學院很榮幸有此機會與金賽收藏合作，首次於亞洲呈現關於非洲裔美國人歷史和文化的展覽。《水盡雲起——金賽收藏之非洲裔美國人的藝術及歷史》展覽，聚焦於此歷史悠久的族裔，突出展現他們取得的藝術和社會成就，以及對人類的貢獻。

無與倫比的金賽收藏具有多層次的魅力。金賽家族已經匯集收藏並策展組織眾多歷史資料和藝術品，細述非洲裔美國人對美國歷史、經濟和文化發展的重要貢獻。金賽收藏的文獻價值非常之高，涵蓋四百年歷史，並清晰描摹非洲裔族群的空前成就，他們通常面對巨大的社會不公，卻依舊在「美國夢」中尋得一席之地，並取得全球傳頌的經濟與社會成功。

「水盡雲起」並非是局部的美國歷史現象，而在亞洲亦屢見不鮮。此次展覽是金賽收藏第一次走出美國，其中展出的文獻和藝術品，與非洲移民及其生命故事息息相關；但是超越此特定群體之外，這些收藏亦代表社會參與和成功，包容和隔離，以及少數族裔在當今愈發全球化的世界中的巨大貢獻。無論東方、西方，少數族裔的成績與政治自由理應得到世人認可，以發展壯大其獨有文化。

香港大學很榮幸展示此主題，並向公眾推廣。感謝金賽家族提供此合作機緣，公開展示如十六世紀浸禮記錄般古老的歷史檔案，以聚焦於非洲裔族群的輝煌歷史，為世界上同樣堅忍的其他少數族群樹立榜樣，而香港亦感同身受。

FOREWORD
前言

PROFESSOR DEREK COLLINS
DEAN, FACULTY OF ARTS,
THE UNIVERSITY OF
HONG KONG

The Faculty of Arts at the University of Hong Kong is delighted to partner with the University Museum and Art Gallery to bring The Kinsey African American Art and History Collection to Hong Kong. This is the collection's debut outside the United States, its first footstep into Asia, and there is a story in it for everyone.

It is not possible to understand the story of America without appreciating the contributions of generations of Africans, Euro Africans, and African Americans to that story. Some contributed with their lives, their labour and their sorrows. Others contributed with their discoveries, their dreams and their art. One doesn't have to be a historian to know that America wouldn't exist today were it not for its immigrants, were it not for its slaves and were it not for its slow, and at times painfully difficult, efforts to recognise first the human, and then the civil rights of its citizens. That pathway to citizenry was anything but straight.

You will meet many of these individuals in this exhibition. Some you will have heard of, others not. I daresay you will be challenged by their accomplishments, exhilarated to learn the odds under which they succeeded and pleasantly surprised by how well some of them did succeed. What is exciting about The Kinsey Collection is the relentless spirit that animates these documents, historical artefacts, and the self-expressions in art. The collection glitters with the achievements of a determined and hopeful people, whose hopes and dreams are in some ways no different than many of ours today. But this is part of the American story that is still being told, even now, and unsettling the narrative that many of us think we already know about America.

香港大學文學院很高興能與香港大學美術博物館合作，一起將金賽收藏之非洲裔美國人的藝術及歷史介紹入香港。今次展覽是金賽收藏首次走出美國，以及首次進入亞洲。希望所有觀眾皆可從收藏之中尋得共鳴。

若不能重視每一代非洲人、歐裔非洲人及非裔美國人對美國歷史的貢獻，則絕對無法全然了解美國故事。有人為之奉獻生命、勞動及血淚，有人則貢獻其發現、夢想及藝術。我們不需成為歷史學家都可明白，若失去移民與舊日奴隸，則無今日之美國。通往公民社會的道路非一帆風順，即從認受人權至承認公民權，不僅緩慢，有時亦極為痛苦困難。

觀者將認識是次展覽中的許多人物，有些知名，有些則默默無聞。我敢斷言，觀者必為他們的成就感到欽佩及振奮。金賽收藏以其不屈不撓的精神，為這些文獻、歷史文物及抒發自我的藝術賦予生命，亦是此批收藏最為動人之處。此一族群的成就於金賽收藏之中發光發亮，他們無比堅決和樂觀，其希望與夢想恰與今日的我們並無二致。這一部分的美國故事，如今依然受人傳頌，並動搖著許多人對美國原有的認知。

孔德立教授
香港大學文學院院長

It is fitting that The Kinsey Collection makes its debut outside the U.S. in Hong Kong. As a glittering, vibrant, open and globally connected city, the citizens of Hong Kong will find many kindred spirits in this collection. If you only have one "aha" moment while experiencing this exhibition, then in my view all of our efforts to bring this collection to Hong Kong will have been worth it: because in that moment, you will recognise yourself.

We thank the Kinseys—Bernard, Shirley and Khalil—for sharing their extraordinary collection with us. Their vision to share their treasures and their lifelong passion for collecting with Hong Kong should be deeply admired.

金賽收藏將美國之外的首展定於香港是極為合適的。香港是一個閃耀、
活力、開放、全球互聯的城市，而香港公民將從此收藏中尋得許多精
神共鳴。哪怕觀者只得一次會心之歎，則對我而言，將金賽收藏帶入
香港的努力辛勞便已值得，因為在當時當刻，你將認識自己。

感謝金賽家族的 Bernard、Shirley 和 Khalil，向香港公眾慷慨展示其
非凡卓越的收藏及其對收藏的終生熱愛，令吾等甚為欽佩。

FOREWORD
前言

BERNARD W. AND SHIRLEY POOLER KINSEY

Our first visit to China was in 1980, Beijing to Shanghai with stops in between. Experiencing Chinese history and culture up close further inspired our interest in understanding more about our very own culture. We visited Hong Kong for the first time in 1982, then again in 1986 and made many friends along the way—returning to this incredible city several times over the last 30 years. For many reasons it is quite special for us to now have the opportunity to share our own history and culture through The University of Hong Kong in a city that we love.

We strive to live our lives on two simple principles: To whom much is given much is required, and to live a life of no regrets. We have been blessed immeasurably and it is with this in mind that we see ourselves as caretakers and stewards of this exhibit.

The real history of African American triumphs and contributions should no longer remain a secret. It should explode into our classrooms and into our collective conscience or consciousness. The stories we highlight in this exhibition show what we have learned about ourselves and our history, particularly that black people have been a part of everything that has happened in Central, South, and North American history from the beginning. The impact and influence of African Americans on American history is often taken for granted and overlooked, though in fact nearly everything in the U.S., from the 17th through the 19th centuries, was built by African Americans. The ultimate example of this is the nation's capital in Washington, D.C., where African Americans built the White House and the Capitol, and contributed to the layout of the entire city.

我們於一九八零年首次造訪中國，期間經停北京與上海。這段近距離體驗中國歷史和文化的旅程，恰恰進一步激發我們深入探究自我獨有的文化。一九八二年和一九八六年，又先後兩次來到香港，途中廣結良朋，並於之後的三十年中頻繁來往這個不可思議的城市。基於種種機緣，終有幸於香港大學和這個我們熱愛的城市之中，親身分享我們的歷史和文化。

我們致力於以兩個簡單的原則生活：凡受惠者必施於人，以及，活得無悔無憾。我們一直沒有忘記上天的眷顧，亦因如此，我們視自己為這次展覽的守護者、監護人。

有關非裔美國人的成就與貢獻的真實歷史，不應再秘而不宣，反而值得耀世而發，於課堂之內研究傳頌，於群體良知和意識之中流淌延存。是次展覽中講述的故事，使觀者認識自我和歷史，特別是黑人由始至終就是中美、南美和北美歷史的一部分。非裔美國人對美國歷史的影響通常被理所當然地忽視，但是事實上從十七世紀至十九世紀，幾乎所有美國的事物都是由非裔美國人所建立。最典型的例子即首都華盛頓特區，非裔美國人於此處建造白宮及國會，並為整個城市規劃作出貢獻。

Our collection became an exhibit in 2006, and over the past 10 years has been shown in 24 cities across the United States, with Khalil now working alongside us. It was the first privately owned collection to be displayed at the Smithsonian National Museum of American History, one of the most visited museums in the world. Part of the collection is now on display at Epcot, Walt Disney World in Orlando, Florida where 15–20 million people are expected to visit.

Through collecting we have found that the artistic endeavors of a people often record it's history and culture. The historical documents, letters and books that we acquired helped to fill in many blanks along the way. Although we have not filled in all the blanks of our personal history and ancestry, we have decided to collect what we call our "collective ancestry". The wonderful stories of our people who helped build America and make it the great nation it is today. Those whose DNA flows through our veins and whose legacy we are proud of and strive to carry on.

The Kinsey African American Art and History Collection grew out of our search to know who we are and where we came from, and a desire to share that knowledge with our son, Khalil, as he grew. What we collect reflects our self-discovery, our individual and personal history and memories of growing up in Florida. We have never strayed too far emotionally from those roots. The collection is where art and history intersect, containing a balance of rare and authentic historical objects and fine art from 1595 to the present, which shares the incredible experience and contributions of African Americans that are often left out of American History books.

We thank members of The University of Hong Kong for being the first international site to exhibit The Kinsey African American Art and History Collection. It is with great appreciation that we thank President Peter Mathieson, Dean Derek Collins, Museum Director Florian Knothe, and all of the faculty and staff that has been a part of this great endeavor.

It is our hope that this experience will educate and inspire, as well as provide a context to further understand the complexities of race in contemporary society and American History.

Our journey continues,
Bernard and Shirley Kinsey

我們的藏品於二零零六年開始展覽，在過去十年期間於美國二十四個城市展出。現在，Khalil 亦與我們同行。金賽收藏是首間於史密森尼學會管理的美國國家歷史博物館中展出的私人收藏，此館是全世界獲最多人參觀的博物館之一。部分金賽收藏還長期駐展於佛羅里達州奧蘭多迪士尼世界的「艾波卡特」主題公園，預計有一千五百萬至兩千萬人到訪。

我們從收藏的過程中發現，從事藝術者經常為記錄歷史和文化而不遺餘力。我們收藏的這些歷史文檔、信箋和書籍在不斷彌補認知。我們雖則未能為自身的歷史和祖先填補所有空白，只得現先稱之為「集前人之大成」，以訴說我族裔建設美國的動人故事，如何使之成為現今的泱泱大國。我們為擁有共同血統的人而感到自豪之餘，亦力求遺志得以長存。

我們從金賽收藏之非洲裔美國人的藝術及歷史中找到根源，並渴望把這份知識與兒子Khalil分享，以陪伴他成長。藏品使我們自發深省，反映個人的親身經歷以及在佛羅里達州的成長回憶。我們從未忘本。這批藏品是藝術和歷史的交匯，當中包括一五九五年至今的稀有歷史文物和藝術真品，分享美國歷史書中往往備受忽視的非裔美國人的重要貢獻和經歷。

衷心感謝香港大學，為金賽收藏首次走出美國的國際展覽提供機會。感謝香港大學馬斐森校長、香港大學文學院孔德立院長、香港大學美術博物館羅諾德總監，以及相關的所有部門和職員。

希望是次展覽能教育、激勵觀眾，啟發理解和沉思，並進一步提供美國複雜的種族背景及全面的美國歷史情況。

旅程還在繼續，
金賽家族之 Bernard・Shirley

水盡雲起精選

SELECTIONS FROM RISING ABOVE

The Baptismal of Estebana, a daughter of Gratia, a slave is baptised on the fifth day of January 5, 1595 by Father Francisco de Marron in St Augustine Catholic Diocese, FL. This is the earliest known baptismal record of African American presence in what later becomes the present day United States, establishing the existence of African Americans twelve years before the founding of Jamestown.

Translation:

[margin:] Estebana

On the fifth day of January, (15)95, I, Father Marron, priest and vicar of this Holy Church, baptised Estebana. She is the daughter of Gratia, slave of [broken]-talita. This being true, I sign my name, Friar Francisco de Marron

奴隸 Estebana 是 Gratia 的女兒，其浸禮於一五九五年一月五日在佛羅里達州聖奧古斯丁天主教教區，由 Francisco de Marron 神父施行。此為已知最早的非洲裔浸禮記錄，這證明在詹姆斯鎮建立十二年前已經有非洲裔居民存在。

翻譯：

Estebana

（一五）九五年一月的第五日，我，Marron 神父，此聖堂牧師和代理，為 Estebana 施行浸禮。她是 Gratia 的女兒，【頁面破損】的奴隸。此乃真切，我署姓名，Friar Francisco de Marron

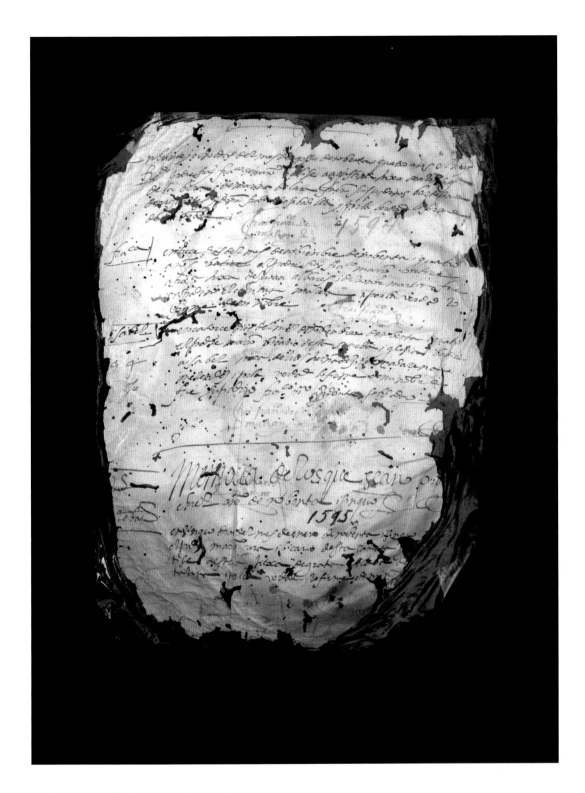

Earliest Known Black Baptismal Record

已知最早的黑人浸禮記錄

1595

St. Augustine, Florida

Ink on paper

This document is a facsimile and on display with special permission

from the Catholic Archdiocese of St. Augustine, FL.

Ignatius Sancho (1729–1780) was born a slave on a ship crossing the Atlantic from Africa to the West Indies. He was taken to Greenwich, England, where he became a butler to the Montagu family, eventually retiring to run a grocery in Westminster. He acted in several plays on the London stage, and is thought to have performed in Othello, making him the first black actor to play the Moorish king.

Sancho also composed music and wrote poems and essays, posthumously published in this volume in 1782. The engraved frontispiece is after the portrait of Sancho painted by Thomas Gainsborough. Sancho, known as "The Extraordinary Negro," became a symbol of the humanity of Africans to 18th-century British abolitionists. He was also the first African to vote in a British election.

Ignatius Sancho（一七二九年至一七八零年）生而為奴，出生於一艘由非洲跨越大西洋駛往西印度群島的航船。他後被運往英格蘭格林尼治，成為 Montagu 家族的男僕；退休之後，最終在西敏經營一間雜貨店。他曾於倫敦參演多部舞台戲劇，更出演《奧賽羅》，這使其成為扮演摩爾王的第一位黑人演員。

Sancho 亦創作音樂、詩歌及散文。他去世之後，這些作品皆被收錄於此套一七八二年的書籍之中。其卷首插畫，以托馬斯·庚斯波羅（Thomas Gainsborough）為 Sancho 繪製的肖像為基礎製作。Sancho 被稱為「非凡的黑人」，成為十八世紀英國廢奴主義中的非洲族裔代表。他也是第一位參與英國大選投票的非洲人。

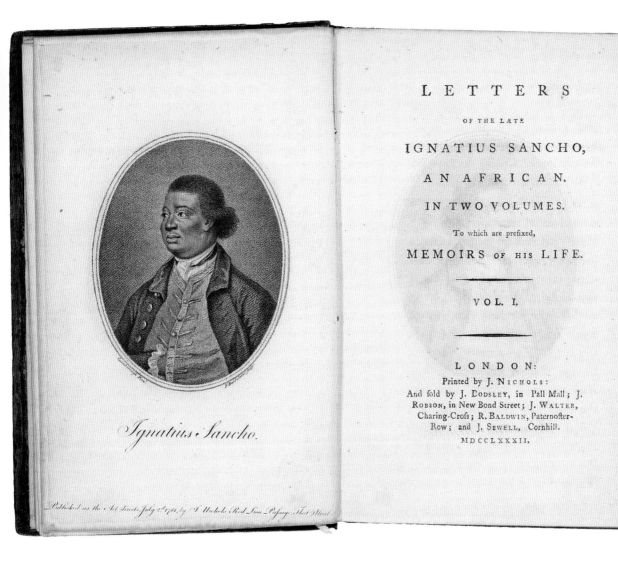

Letters of the Late Ignatius Sancho, an African,
in Two Volumes
《非洲人 Ignatius Sancho 信札》共兩卷
1782
Ignatius Sancho
Book
8 x 5 ½ x 2 in.

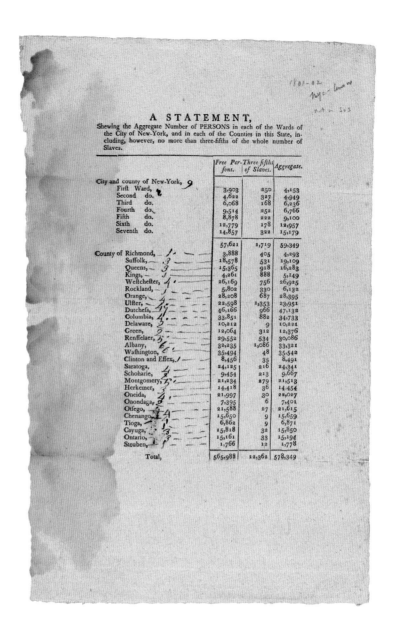

New York Census
紐約人口普查
1801
State of New York
Printed paper
8 ¾ x 5 ¾ in.

According to the 1787 Philadelphia Convention and the compromise between Northern and Southern states, slaves were to be counted in the census as three-fifths of a person. The compromise, which was reached in the effort to unite the Northern and Southern states, was reflected in the Constitution in Article 1, demonstrating that slavery was codified in the country's foundational documents. The first U.S. census took place in 1790. This document shows the "three-fifths compromise" taking effect in the New York census of 1801.

根據一七八七年費城會議以及南北方各州之間的和解方案，每位奴隸將在人口普查中被計為五分之三人。為團結南北各州而達成的此項協議，在《美國憲法第一條》中得到確認，這顯示奴隸制已被編入國家基本文件之中。第一次美國人口普查於一七九零年展開。此份文件即展示一八零一年紐約州人口普查中生效的「五分之三妥協」。

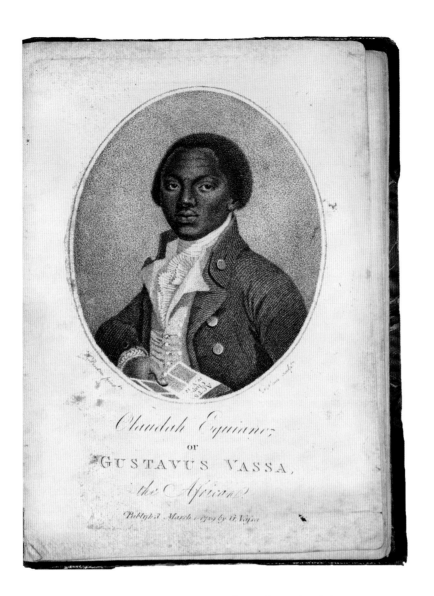

The Interesting Narrative of the Life of Olaudah Equiano, or Gustavus Vassa, the African
《非洲人Olaudah Equiano 或名 Gustavus Vassa 的有趣故事》
1789
Olaudah Equiano
Book
7 ½ x 4 ¼ x 1 ¼ in.

A contemporary of Sancho, Olaudah Equiano was captured by African slavers near his home on the Niger River and sold into the transatlantic slave trade. He was purchased by an officer in the British Royal Navy, who taught him seamanship and navigation. Later, Equiano was sold to a Quaker who helped him become more literate and allowed him to buy his freedom. To promote the abolitionist cause he wrote of his life as a slave. This work is one of the few first-person narratives documenting the life of those destined for slavery on the transatlantic slave routes.

作為 Sancho 同時代的人，Olaudah Equiano 在其尼日河旁的家附近被非洲奴隸販捕獲，並被賣往穿越大西洋的奴隸貿易之中。一位英國皇家海軍軍官將 Equiano 買下，還教他航海技術與導航術。之後， Equiano 被出售給一位貴格會教徒，他不僅幫助 Equiano 識字，更為他贖身。 為推動廢奴事業的發展，他將自己的奴隸生涯寫入此書，這是為數不多的以第一人稱視角記述大西洋奴隸貿易中奴隸生活的書籍。

Charlottsville April the 3d 1854

Messers Dickerson & Hill

This will be handed you
by my servant Frances. I am told that it is useless to give
the capabilities of a servant, that it depends allogather on
there personal appearance; be that as it may. I say
positively that she is the finest chamber-maid I have ever
seen in my life, she is a good washer, but at house cleaning
she has perfect slight-of-hand. She is 17 teen years old the
eleventh of this month

She does not know that she is to be sold. I could not tell
her; I own all her family, and the leave taking would
be so distressing that I could not. Please say to her
that that was my reason, and that I was compelled to
sell her to pay for the horses that I have baught, and
to build my stable. I believe I have said all that is
necessary, but I am so nervous that I hardly know
what I have writen. Respectfull Yours

A M F Crawford

A Slave Carrying Her Fate in Her Hands
奴隸女孩將命運奉上
1854
A.M.F. Crawford
Printed paper
19 ¾ x 12 ½ in.

This letter documents the commodification of black bodies in stark terms. Frances, the young girl carrying her fate in her hands, and helpless to change the situation, is being sold away from her family so that her owner can use the proceeds for other purchases. The owner, though aware of Frances' abilities and value, is exclusively concerned with her own economic and emotional circumstances:

"This will be handed you by my servant Frances. I am told that it is useless to give the capabilities of a servant, that it depends altogather [sic] on there [sic] personal appearance; be that as it may. I say positively that she is the finest chamber-maid I have ever seen in my life, she is a good washer, but at house cleaning she has perfect slight of hand. She is 17teen [sic] years old the eleventh of this month.

"She does not know that she is to be sold, I couldn't tell her; I own all her family and the leave-taking would be so distressing that I could not. Please say to her that that was my reason, and that I was compelled to sell her to pay for the horses that I have bought, and to build my stable. I believe I have said all that is necessary, but I am so nervous that I hardly know what I have written. Respectfully Yours AMF Crawford."

此封信中的冰冷條款，將黑人的身體視作商品。Frances 是一位年輕的奴隸女孩，手捧一封決定自己命運的信件，卻並無能力改變現狀。她的主人將她出售換錢，用以購買其他物件。這位奴隸主雖然意識到 Frances 的能力與價值，卻依然只關心她的金錢回報和情緒狀態：

「此信由我的僕人 Frances 奉上。我聽聞，推銷僕人時無需強調其做事能力，而只應關注其外貌條件。但恕我斗膽多言，Frances 是我此生見過最優秀的侍女。她擅長洗衣洗碗，打掃屋院之時亦能十分靈巧。本月十七號，她將年滿十七歲。

Frances 至今仍不知自己將被出售，我也難以啟齒，因為她全家人都是我的奴隸，所以離開的消息必定使她萬分痛苦沮喪。請轉告她，我亟需償還最近的購房款，以及修建馬廄，所以不得不將她出售換錢。我相信我已將所有必要信息知會於您，但我卻如此緊張，以至有些不知所云。順頌祺安，AMF Crawford。」

During this period, healthy and childbearing slaves often sold for as much as $1,800. Mary Ann Graham sold Henry Butler his family—his wife and four children—at a significant loss; the entire transaction involved only $100. This letter is extremely important to the Kinseys because it shows the compassion of the female slave owner. It offers a glimpse of humanity at an otherwise inhumane time.

在當時年代，健康且適齡生育的奴隸通常能被賣至一千八百美金。Mary Ann Graham 以虧本的價格將 Henry Butler 的家人轉讓於他，共包括其妻子及四個孩子，而全部交易只有一百美金。此封信對金賽家族十分重要，因為其展現女性奴隸主的憐憫之心，使我們一睹那個非人道年代中閃耀的人性光輝。

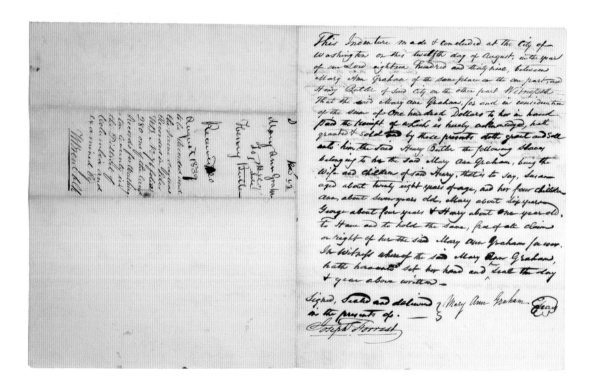

Henry Butler Buys the Freedom of His Wife
and Four Children for $100
Henry Butler 花費一百美金為妻子與四個孩子贖身
1839
Henry Butler
Ink on paper
9 x 14 ½ in.

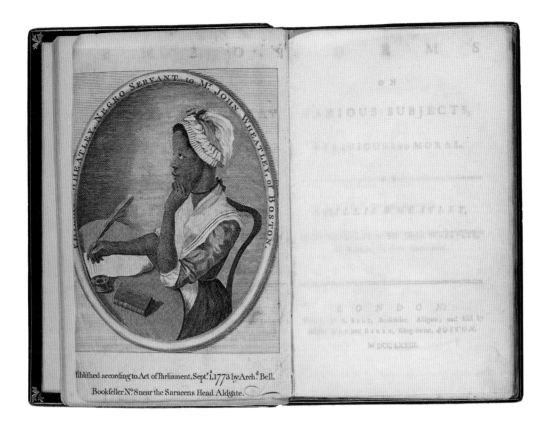

Born in Gambia around 1753, Phillis Wheatley was sold into slavery and transported to the New World on the slave ship Phillis, after which she was named. In Boston, she was purchased by John Wheatley, a merchant. Wheatley and his wife Susanna educated Phillis and she excelled under their tutelage. She mastered Latin and Greek as well as history and geography, and began writing poetry when she was 13 years old. Wheatley, the first published African American woman poet, is regarded as a founding figure of black literature. And her work was only the third book of poetry to be published by an American woman. Her portrait printed in the book is the only surviving work by the African American slave artist Scipio Moorhead.

Poems on Various Subjects—
Religious and Moral
《萬物詩──關於宗教與道德》
1773
Phillis Wheatley
Book
7 ¾ x 5 ¼ x 1 ½ in.
Courtesy of Larry Earl

菲利絲·惠特蕾（Phillis Wheatley）約一七五三年生於甘比亞，之後被賣作奴隸，並被「Phillis 號」販奴船運往「新世界」，而她也因此以船為名。商人 John Wheatley 在波士頓將其買下，更與妻子 Susanna 一同教育、培養菲利絲；而她也不負二人心血栽培，終於出類拔萃。菲利絲精通拉丁語和希臘語，擅長歷史與地理，而且十三歲時便開始創作詩歌。菲利絲·惠特蕾是有作品發表的第一位非洲裔美國女性詩人，這亦是美國女性出版的第三本詩集，她也被視作黑人文學奠基人。書中的肖像是非洲裔美國奴隸藝術家 Scipio Moorhead 唯一存世至今的作品。

Contemporary artist Gayle Hubbard enhanced this *Harper's Weekly* cover illustration "The First Vote" with watercolours. The power of the image was recognised and promoted by the publication's editors, who wrote in 1867:

"The good sense and discretion, and above all the modesty, which the freedmen have displayed in the exercise, for the first time, of the great privilege which has been bestowed upon them, and the vast power which accompanies the privilege, have been most noticeable. Admiration of their commendable conduct has suggested the admirable engraving which we give on the first page of this issue. The freed-men are represented marching to the ballot box to deposit their first vote, not with expressions of exultation or of defiance of their old masters and present opponents depicted on their countenances, but looking serious and solemn and determined. The picture is one which should interest every colored loyalist in the country."

當代藝術家 Gayle Hubbard 運用水彩顏料，加強這幅《Harper's Weekly》封面圖——第一票。一八六七年的出版編輯意會到這幅圖畫的力量，並撰寫如下文字：

「這是自由民第一次享受此項偉大的天賦民權，並行使隨之而來的巨大權利，他們藉此表現出的品質，如智慧、決斷，以及最重要的謙遜，皆被廣泛察覺。懷著對其端正品行的欽佩之情，我們特意將其影像鐫刻於此刊卷首。畫面中，被解放的奴隸正排隊前往票箱行使他們的第一票，但臉上卻並無狂喜之色，也無絲毫對舊日奴隸主以及今日對手的蔑視，反而是無比嚴肅、莊嚴、堅定。此幅圖畫應能受到每一位反歧視人士的關注。」

The First Vote
第一票
Gayle Hubbard
Watercolour painted on a facsimile of
Harper's Weekly, November 16, 1867
20 x 16 in.

HARPER'S WEEKLY.

A JOURNAL OF CIVILIZATION.

VOL. XI.—No. 568.] NEW YORK, SATURDAY, NOVEMBER 16, 1867. [SINGLE COPIES TEN CENTS. $4.00 PER YEAR IN ADVANCE.

Entered according to Act of Congress, in the Year 1867, by Harper & Brothers, in the Clerk's Office of the District Court for the Southern District of New York.

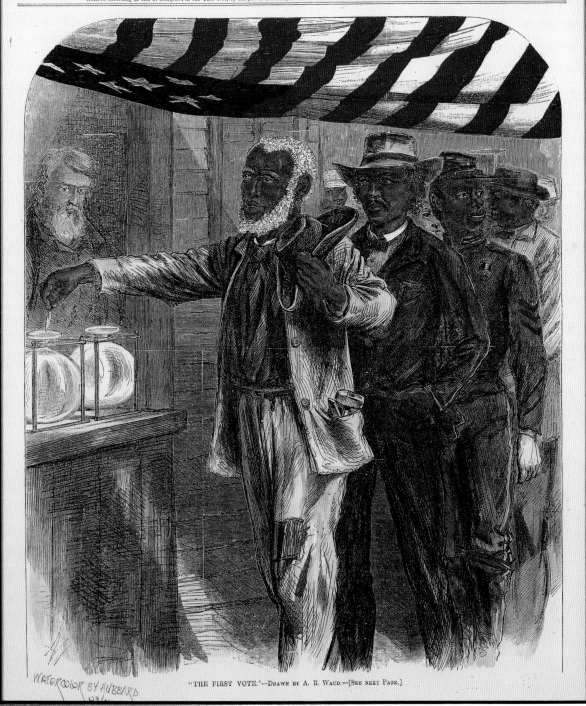

WATERCOLOR BY HUBBARD

"THE FIRST VOTE."—Drawn by A. R. Waud.—[See next Page.]

Left to right: Senator Hiram Revels of Mississippi, Representatives Benjamin Turner of Alabama, Robert DeLarge of South Carolina, Josiah Walls of Florida, Jefferson Long of Georgia and Joseph Rainey and Robert Brown Elliot of South Carolina.

Of the 22 African American men who served in the United States Congress between 1870 and 1901, 13 of them had been born into slavery. Hiram Rhoades Revels, Josiah Walls and Robert Brown Elliot were born to free parents. Regardless of their backgrounds and the discrimination they faced in securing their seats, these men championed the rights of all Americans, proving that African Americans could succeed in the framework of a democratically elected legislature.

由左至右：密西西比州參議員 Hiram Revels，阿拉巴馬州眾議員 Benjamin Turner，南卡羅來納州眾議員 Robert DeLarge，佛羅里達州眾議員 Josiah Walls，佐治亞州眾議員 Jefferson Long，南卡羅來納州眾議員 Joseph Rainey，南卡羅來納州眾議員 Robert Brown Elliot。

一八七零年至一九零一年間，共有二十二名非洲裔美國人於美國國會任職，其中有十三人生而為奴。Hiram Rhoades Revels、Josiah Walls 與 Robert Brown Elliot 生於自由民家庭。且不論他們的背景，以及為保護席位而遭受的歧視，這些人是在捍衛所有美國人的權利，亦證明非洲裔美國人有能力在民主投票的立法機構中取得成功。

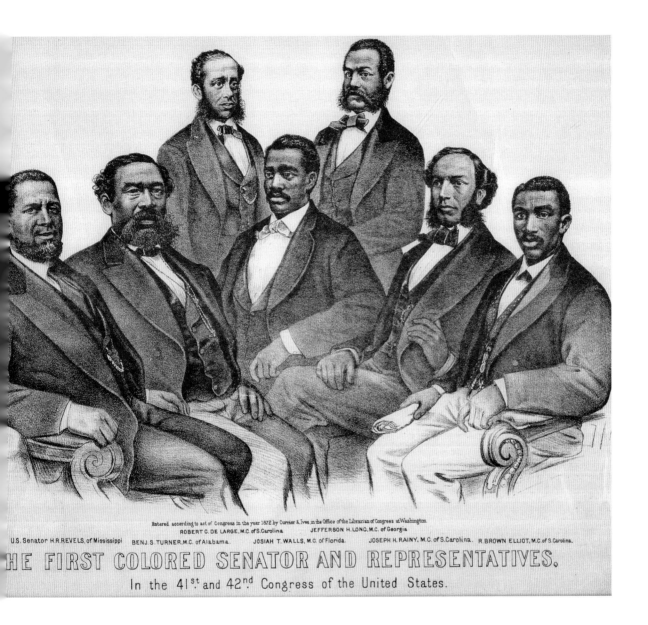

The First Colored Senator and Representatives in the 41st
and 42nd U.S. Congress of the United States
第四十一屆與第四十二屆美國國會中的首批有色人種參議員和眾議員
1872
Currier and Ives
Lithograph
24 x 18 in.

Blacks were banned from military combat until late 1862, despite pleas and petitions demanding inclusion in the war effort. As the ban was lifted, black leaders, including Frederick Douglass, encouraged blacks to join the fight. The Bureau of Colored Troops was formed to recruit and register black volunteers for the Union Army.

Roughly 180,000 blacks served as Union soldiers during the Civil War. Following the Emancipation Proclamation, black troops were allowed to fight as Union soldiers. This is one of the first recruiting posters used to promote black service.

儘管戰爭期間有無數請願，但黑人依然被禁止參軍；直到一八六二年末禁令取消，包括弗雷德里克·道格拉斯（Frederick Douglass）在內的黑人領袖開始鼓勵黑人踴躍參軍戰鬥。政府成立有色軍管理局為聯邦軍招募、註冊黑人志願者。

美國南北戰爭中，約有十八萬黑人士兵參加聯邦軍。根據《解放奴隸宣言》，黑人軍團被允許為聯邦軍參戰。此圖為最早的徵兵海報之一。

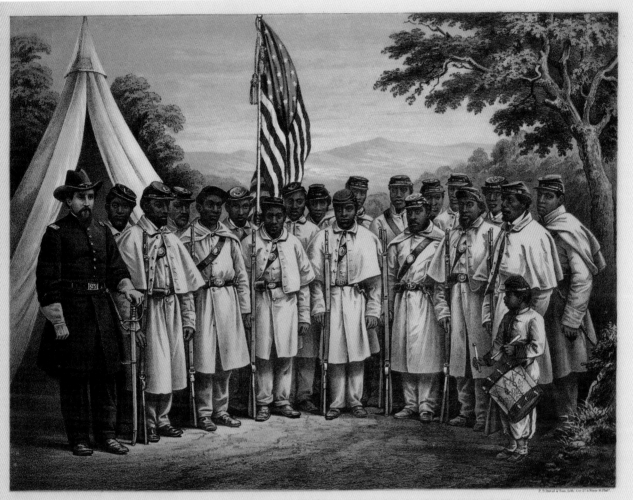

United States Soldiers at Camp William Penn
威廉佩恩軍營中的美國士兵
1863
Supervisory Committee for Recruiting Colored Regiments
Chromolithograph print
22 ½ x 25 in.

Duncanson, born in Seneca County New York, began his professional life as a portrait painter but was drawn to landscapes; his work was greatly influenced by the Hudson River School. He was commissioned to do several large murals in Cincinnati, and these were well received, enabling him to live off the proceeds of his work. Later, he traveled to Britain to study and paint landscapes. The *London Art Journal* declared him a master painter. After his death, however, his work fell into obscurity. It was not until the 1950s, when James Porter dedicated himself to reclaiming Duncanson's contribution to African American art, that the public rediscovered his work.

Duncanson 生於紐約瑟內薩縣，最初以肖像畫家的身份開始藝術生涯，之後才轉而癡迷風景畫，並深受「哈德遜河派」影響。他曾受邀在辛辛那提創作數件大型壁畫，結果廣受好評，這使他得以藉此收入為生。之後他前往英國遊學並創作風景畫，《London Art Journal》更稱他為繪畫大師。但是在他去世之後，其作品卻變得默默無聞。直到一九五零年代，James Porter 窮盡畢生心力，在非洲裔美國人藝術領域中為 Duncanson 正名，公眾才得以重新認識這些作品。

Landscape, Autumn
秋日風景
ca. 1865
Robert Scott Duncanson
Oil on board
16 ¾ x 13 ¼ in.

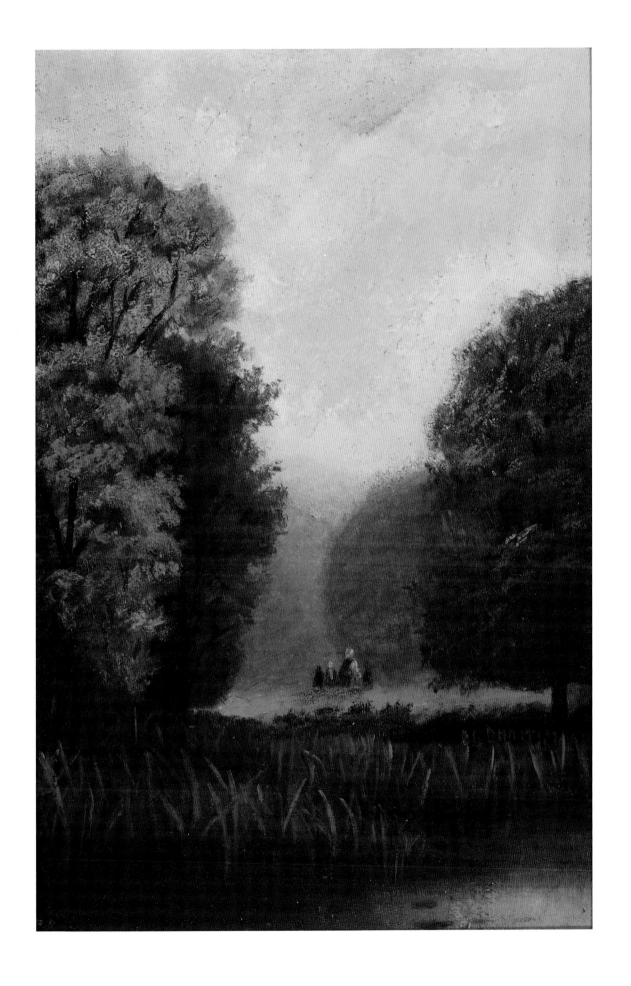

Twelve Years a Slave is a memoir and slave narrative by Solomon Northup as told to and edited by David Wilson. Northup, a black man who was born free in New York, details his kidnapping in Washington, D.C. and subsequent sale into slavery. After having been kept in bondage for 12 years in Louisiana by various masters, Northup was able to write to friends and family in New York, who eventually secured his release. Northup's account provides extensive details on the slave markets in Washington, D.C. and New Orleans, as well as describing at length cotton and sugar cultivation on major plantations in Louisiana.

《被奪走的十二年》是所羅門·諾薩普（Solomon Northup）根據自身經歷口述創作的一部回憶錄式的奴隸敘事文學作品，由 David Wilson 整理編輯著成。諾薩普本是一位生而自由的紐約黑人，卻在華盛頓特區被綁架，並被賣為奴隸。他在路易斯安那幾經易主，經歷十二年奴隸拘禁之後，終於能向自己身在紐約的朋友及家人寫信，並最終被其解救。諾薩普的描述提供關於華盛頓特區與紐奧良奴隸市場的豐富細節，還詳細介紹路易斯安那主要種植園中的棉花與糖種植。

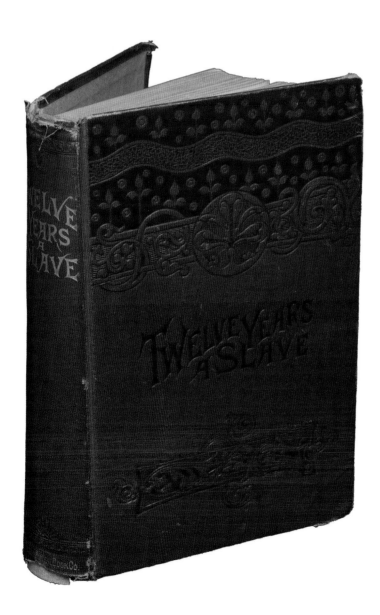

Twelve Years a Slave
《被奪走的十二年》
1892
Solomon Northup
Book
7 ½ x 6 ¼ in.

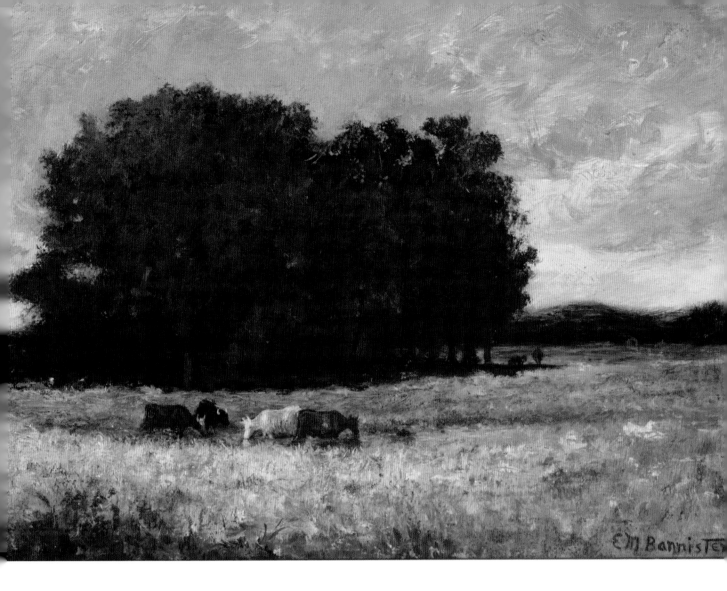

Four Cows in a Meadow
草甸上的四頭牛
1893
Edward Mitchell Bannister
Oil on canvas
16 ¾ x 20 ¾ in.

Bannister, born in Canada, was at a young age encouraged by his mother to paint. He moved to Boston in 1848 and became a barber, but pursued his love of art at the Lowell Institute, studying under the sculptor William Rimmer. Influenced by the Barbizon School, Bannister painted idyllic landscapes with thick impasto. At the 1876 Centennial Exposition in Philadelphia, Bannister's *Under the Oaks* was selected for the bronze medal, the major prize for oil painting. He became a founding member of the Providence Art Club in 1880, and over the years received numerous commissions for his work.

Bannister 生於加拿大，年少時在母親的鼓勵下開始繪畫。一八四八年，他移居波士頓，成為一名理髮師，但在洛厄爾學院發現自己熱愛藝術，並師從雕塑家William Rimmer。Bannister 深受「巴比松派」的影響，以厚塗法繪畫田園風景。在一八七六年的「費城美國獨立百年博覽會」中，Bannister 的作品《橡樹之下》被評為銅牌，即主要的油畫獎項。一八八零年，他成為「普洛維登斯藝術俱樂部」的創建人之一。多年以來，其作品榮獲眾多獎勵。

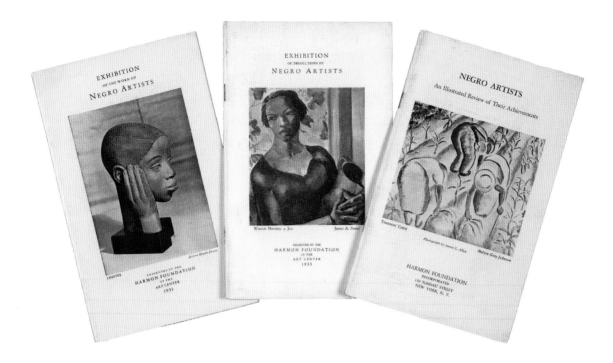

A major supporter of the Harlem Renaissance was the real estate developer William Harmon. He established the Harmon Foundation to celebrate black achievement in the arts and sciences. The foundation sponsored competitions to encourage artists nationwide to join those in Harlem who were creating this new, strong vision of black identity. One Harmon Foundation winner was Hale Woodruff, the first African American to attend Indiana University's prestigious Herron Art School. Other foundation award recipients have included Palmer Hayden, Charles Alston and Aaron Douglas. The Kinseys collect these renowned artists, as well as the Harmon Foundation catalogues that played such an important role in the artists' national and international success. They view these documents as a testament to their own goal of cultivation: recognising greatness, fostering and sharing it with people who want to broaden their knowledge and understanding.

Exhibition of the Work of Negro Artists
黑人藝術家作品展
1931
Harmon Foundation
Exhibition catalog
8 x 5 in.

Exhibition of Productions by Negro Artists
黑人藝術家創作展
1933
Harmon Foundation
Exhibition catalog
8 x 5 in.

Negro Artists: An Illustrated Review of Their Achievements
黑人藝術家：成就回顧展
1935
Harmon Foundation
Exhibition catalog
8 x 5 in.

不動產發展商 William Harmon 是「哈林文藝復興」的主要支持者之一。他成立「Harmon 基金會」，以鼓勵黑人在藝術及科學領域的成就。基金會通過舉辦一系列比賽，吸引遍及全國的藝術家加入「哈林」陣營之中，一齊創造具有強烈黑人身份特徵的新式視覺表現形式。Hale Woodruff, 是「Harmon 基金會」比賽的勝者之一，是進入印第安納大學享有盛名的赫倫藝術學院的第一位非洲裔美國人。基金會獎項的獲獎者還包括 Palmer Hayden、Charles Alston 與 Aaron Douglas。金賽家族不僅匯集這些著名藝術家，還收藏「Harmon 基金會」圖錄，這些圖錄曾助這些藝術家蜚聲宇內。金賽家族將這些收藏視為自我教化的約書：即認識偉大，並與意圖擴寬知識和理解的人們慷慨分享。

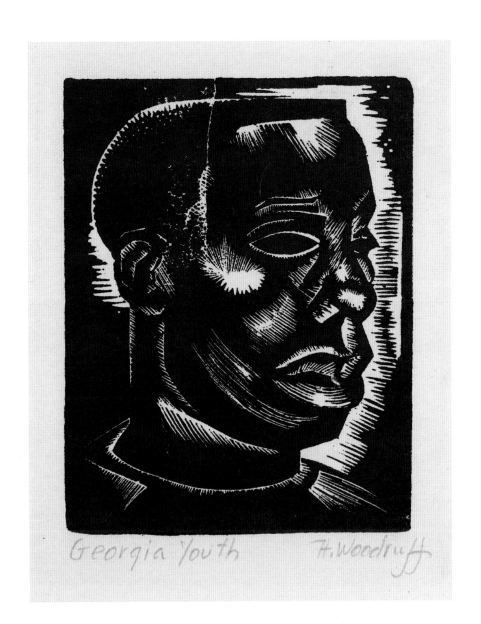

Georgia Youth

Georgia Youth
佐治亞青年
1934
Hale Woodruff
Linocut
17 x 13 ¼ in.

Woodruff was the first African American to attend Indiana's Herron Art Institute. In 1926, he won second prize in the Harmon Foundation competition for painting. Woodruff studied with Mexican muralist Diego Rivera in Paris where his cubist style matured. He joined the faculty at Atlanta University, where he developed the university's art program. Later, Woodruff moved to New York to teach at New York University.

Woodruff 是進入印第安納州赫倫藝術學院的第一位非洲裔美國人。一九二六年，他榮獲「Harmon 基金會」繪畫二等獎。Woodruff 曾師從墨西哥壁畫家迪亞高·里維拉（Diego Rivera），並於巴黎培養出立體主義風格。他進入亞特蘭大大學工作，完善大學的藝術課程。之後，Woodruff 前往紐約大學任教。

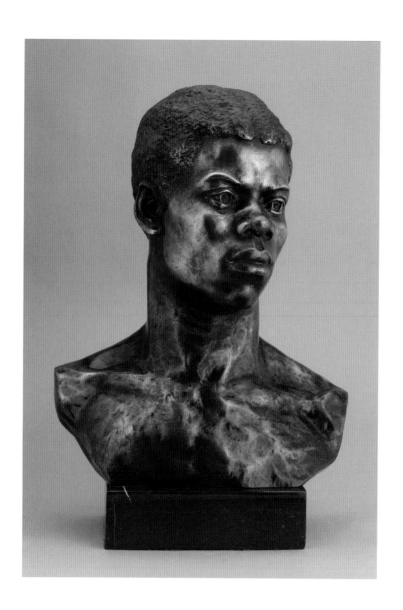

Portrait Bust of an African
非洲人半身像
May Howard Jackson
(original cast of *Slave Boy*,
1899–1900)
Bronze
21 x 12 ¾ in.

Born into a middle-class family in Philadelphia, May Howard Jackson was influential in the worlds of American sculpture and African American artistic pedagogy. She was mentored by pioneering African American sculptor Meta Warrick Fuller, but decided against following Fuller to Paris to continue her studies. Instead, Jackson married, settled in Washington, D.C. and became a mentor and instructor to many other black artists, including James Porter and her husband's nephew Sargent Johnson.

May Howard Jackson 生於費城的一個中產階級家庭，深受美國雕塑世界及非洲裔美國人藝術教育的影響。她拜師於非洲裔美國人先驅雕塑家 Meta Warrick Fuller，但之後卻並未跟隨 Fuller 前往巴黎以繼續學業，而是決定結婚，並於華盛頓特區定居，更在此成為許多黑人藝術家的導師，其中包括 James Porter 以及她丈夫的外甥 Sargent Johnson。

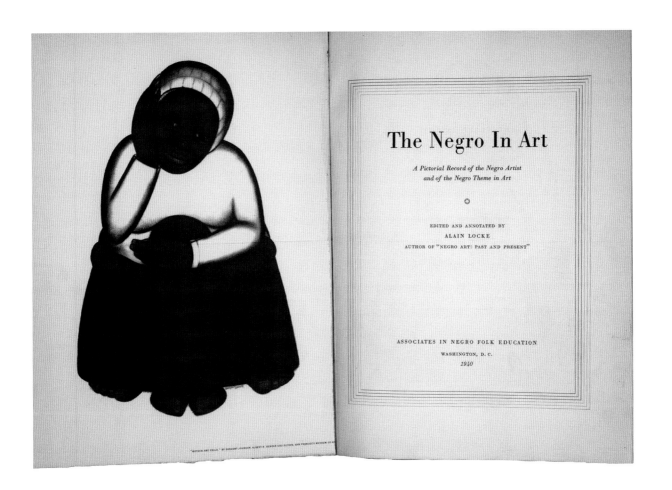

The Negro in Art
《黑人與藝術》
1941
Alain Locke (1886–1954)
Book
12 ¼ x 9 ¼ x 1 in.

A scholar of African American art, Locke was born in Philadelphia and studied philosophy at Harvard College. He became the first African American Rhodes scholar in 1907, and he studied at both Oxford University and in Berlin. Locke later taught philosophy at Howard University and became widely known for his writings on African American culture and art. Locke established the Associates in Negro Folk Education series in order to publish scholarly works about politics, history, literature and art. A book in this series, *The Negro in Art*, features work by black artists and representations of related themes, as well as primitive African art.

阿蘭·洛克（Alain Locke）生於費城，後在哈佛學院攻讀哲學，是一位研究非洲裔美國人藝術的學者。他在一九零七年成為第一位獲得「羅氏獎學金」的非洲裔美國人，並前往牛津大學與柏林進修。洛克之後在侯活大學教授哲學，並因其對非洲裔美國人文化及藝術的研究著述而聞名。他創立「黑人民俗教育」，用以出版學術著作，主題涉及政治、歷史、文學及藝術。作為系列之一，《黑人與藝術》以黑人藝術家的作品、相關主題的展現以及原始非洲藝術等為特點。

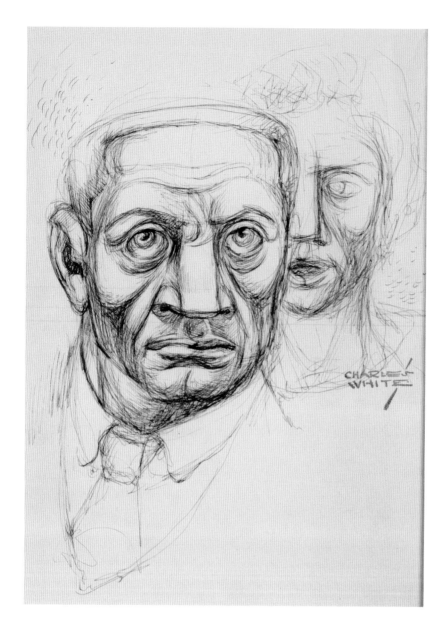

The Couple
夫妻
1940
Charles White
Ink on paper
18 x 14 in.

White began his career at the Chicago Community Arts Center before receiving a full scholarship to the school of the Art Institute. In 1939, he worked as a mural painter for the Illinois Federal Arts Project and later studied at the Art Students League in New York. He made prints at the renowned graphics workshop Taller de Grafica in Mexico City, where he lived for two years. After serving as artist in residence at Howard University, he moved to New York and worked with the Graphic Workshop. White was awarded two Rosenwald Fellowships, and in 1972 was elected a member of the National Academy of Design.

White 的藝術生涯始於芝加哥社區藝術中心，之後在芝加哥藝術學院獲得全額獎學金。一九三九年，他在伊利諾州「聯邦藝術計劃」擔任壁畫師，之後前往紐約藝術學生聯盟學習。他在墨西哥城生活兩年，並於城中的著名圖像工作坊「Taller de Grafica」製作版畫。在侯活大學擔任駐校藝術家之後，他移居紐約並與「Graphic Workshop」合作。White 曾獲得兩項「Rosenwald 獎學金」。一九七二年被選為國家設計學院成員。

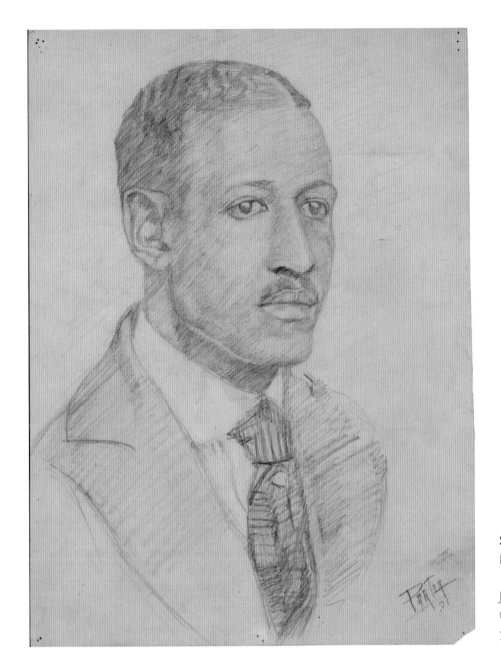

Self Portrait
自畫像
1931
James Porter
Charcoal pencil on paper
24 x 20 ¼ in.

Porter attended Howard University and later joined its art department, where he taught painting and drawing. In 1943, he published *Modern Negro Art*, which sought to acknowledge the achievement of African American artists and to place their work in a broader art context. Porter focused his academic research on black artists who were not recognised by the mainstream, including 19th-century painter Robert S. Duncanson, who he rescued from obscurity.

Porter 進入侯活大學學習，之後又在大學藝術系從事繪畫教育工作。一九四一年，他出版《Modern Negro Art》，力求匯編非洲裔美國人藝術家的成就，並將其作品展示於一個更廣闊的藝術環境中。Porter 的學術研究，重點關注那些仍未得主流認知的黑人藝術家，比如十九世紀畫家 Robert S. Duncanson 即是由 Porter 使之聞名。

Wheeler began her formal arts education at the Pennsylvania Academy of the Fine Arts in 1908. After graduation, she founded the art department of the State Normal School at Cheyney, Pennsylvania, teaching and painting for over thirty years.

Wheeler 所受的正規藝術教育始於一九零八年的賓夕凡尼亞美術學院。畢業之後，她在賓夕凡尼亞州切尼的州立師範學校創立藝術系，在此從事教學及繪畫工作超過三十年。

Woman Wearing Orange Scarf
穿戴橙色頸巾的婦女
ca. 1940
Laura Wheeler Waring
Oil on canvas
17 x 12 in.

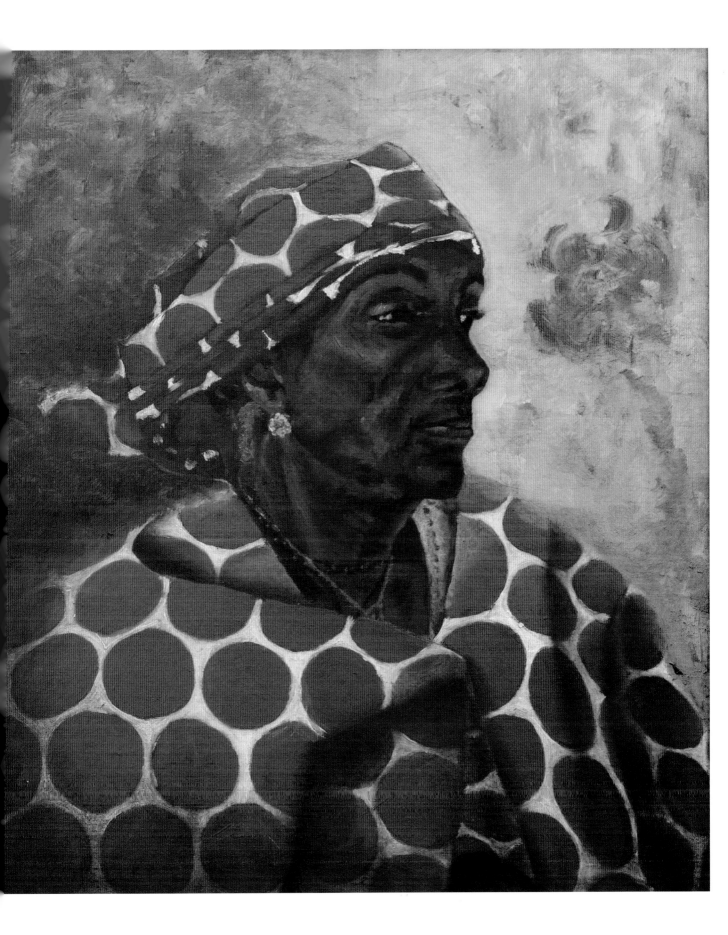

Barthé attended the Art Institute of Chicago and studied painting with Charles Schroeder, who encouraged him to explore three-dimensional art, thus discovering a passion for sculpting. He was awarded two Rosenwald Fellowships, which enabled him to study at the Art Students League and in Paris, and he later received a Guggenheim Fellowship. In 1946, he was inducted into the National Institute of Arts and Letters. His sculptures have been collected by the Whitney Museum of American Art, the Metropolitan Museum of Art and the Smithsonian.

Barthé 進入芝加哥藝術學院,並跟隨 Charles Schroeder 學習繪畫。在導師的鼓勵之下,Barthé 開始探索三維藝術領域,終於發現自己對雕塑的深愛。他曾兩度獲得「Rosenwald 獎學金」,這使他得以前往紐約藝術學生聯盟以及巴黎學習,之後又獲得「古根漢獎學金」。一九四六年,他被引薦入美國藝術文學院。他的雕塑作品被收藏於惠特尼美國藝術博物館、大都會藝術博物館以及史密森尼學會。

The Dancer
舞者
1937
Richmond Barthé
Bronze
17 x 8 x 7 in.
Recipient of the Harmon Foundation Award

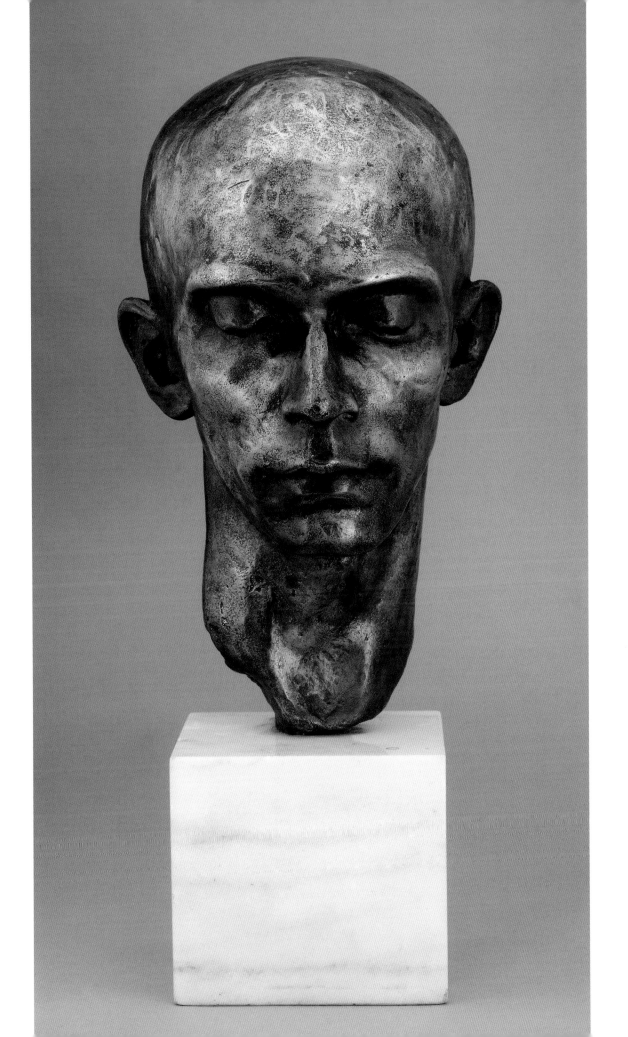

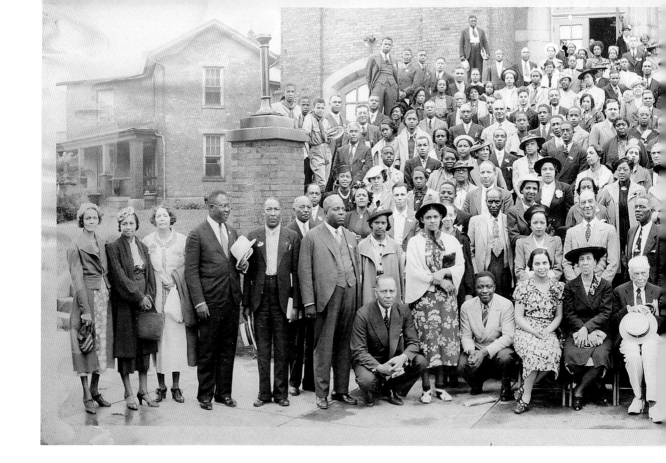

Seated in the center of this group photograph is Walter White, then National Secretary of the NAACP. To the right are Assistant National Secretary Roy Wilkins and Thurgood Marshall, then NAACP special counsel. He was appointed to this position in 1938. Individuals seated include NAACP staff: Juanita Jackson, Dorothy Lampkin, Charles Hamilton Houston, James McClendon, E. F. Morrow and William Pickens. Founded on February 12, 1909, the centennial of Abraham Lincoln's birth, the NAACP is the nation's oldest, largest and most widely recognised grassroots civil rights organisation. Its more than half-million members and supporters throughout the United States and the world are the premier advocates for civil rights in their communities, campaigning for equal opportunity and conducting voter mobilisation.

坐在此幅群組攝影中間的人是 Walter White，即當時的全國有色人種協進會秘書長。他右邊是副秘書長 Roy Wilkins 和特別檢察官 Thurgood Marshall（於一九三八年就任）。坐著的人還包括全國有色人種協進會職員：Juanita Jackson、Dorothy Lampkin、Charles Hamilton Houston、James McClendon、E. F. Morrow 和 William Pickens。美國全國有色人種協進會成立於一九零九年二月十二日，即林肯百年誕辰日，是美國歷史最悠久、規模最大、最被廣泛認同的基層民權組織。其在全國乃至世界各地有超過五十萬會員與支持者，他們皆是社區中最初的民權提倡者，爭取平等機會和組織選民動員。

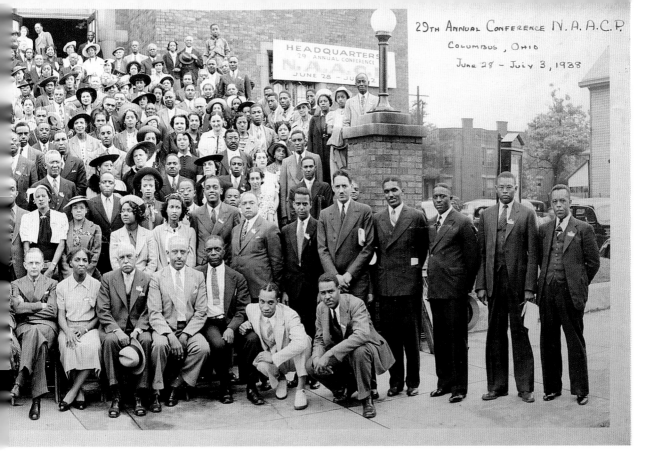

Panoramic Photograph of the 39th Conference of the NAACP
美國全國有色人種協進會第三十九屆大會的全景照
1938
Photographer unknown
Silver print
8 x 29 ½ in.

Merton Simpson (1928-2013) left South Carolina in 1949 to attend New York University and Cooper Union. During college he worked in the frame shop of Herbert Benevy where many well-known artists frequented, including Franz Kline, Max Weber and the Dutch abstract expressionist Willem de Kooning. In 1951, Simpson's work appeared at the Museum of Modern Art and in 1954 at the Guggenheim Museum. By 1955 Simpson had a one-person exhibition at the Bertha Schaeffer Gallery.

In 1963, the Civil Rights Movement led to the formation of the Harlem-based artists' collective, the Spiral Group, of which Simpson was an original founder, along with Romare Bearden, Norman Lewis, Charles Alston, Hale Woodruff, Richard Mayhew and others. For a period, these socially conscious painters focused their work on the black freedom struggle while aiming to create a unique aesthetic that would play a transformative role in the understanding of race and identity in America.

Merton Simpson（一九二八年至二零一三年）於一九四九年離開南卡羅萊納，前往紐約大學與柯柏聯盟學院學習。在大學期間，他為 Herbert Benevy 的設計商店工作，許多著名藝術家常常往來於此，包括 Franz Kline、Max Weber 以及荷蘭抽象表現主義畫家威廉·德·庫寧（Willem de Kooning）。Simpson 的作品於一九五一年展出於現代藝術博物館，一九五四年展出於古根漢美術館。一九五五年，Simpson 在「Bertha Schaeffer Gallery」舉辦個人展覽。

一九六三年，民權運動促使具有哈林背景的藝術家聯合，形成「Spiral Group」，而 Simpson 即是最初的發起人之一，另外還有 Romare Bearden、Norman Lewis、Charles Alston、Hale Woodruff、Richard Mayhew 等人。這些具有社會意識的畫家，長期聚焦黑人爭取自由的鬥爭，同時創造出一種獨特的審美觀，用以變革美國國內的種族與身份觀念。

Sky Poems
天空之詩
1941
Merton Simpson
Oil on board
24 x 24 in.

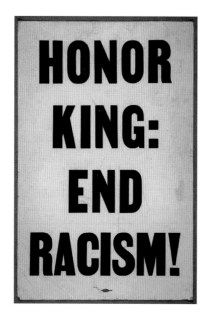

This placard was carried during the memorial march in honour of Dr Martin Luther King, Jr, held on April 8, 1968, in Memphis, Tennessee. The procession was led by Mrs King and three of her children while national guardsmen lined the streets, poised on M-48 tanks with helicopters circling overhead. Mrs King led another funeral procession of 150,000 in Atlanta the next day.

On April 3, 1968, King addressed a rally and delivered his "I've Been to the Mountaintop" address at Mason Temple, the world headquarters of the Church of God in Christ. At 6:01 pm on April 4, he was shot while standing on the second floor balcony of the Lorraine Motel. The assassination led to a nationwide wave of marches and riots in more than 100 cities.

一九六八年四月八日，在美國田納西州孟斐斯市展開一場紀念馬丁路德金的遊行，而遊行者即手持此種標語牌。遊行隊伍由馬丁路德金夫人及其三個孩子帶領，而國民警衛隊亦在街上列隊，昂首站於M48坦克之上，還有直升機在頭頂上空盤旋。一日之後，金夫人又在亞特蘭大帶領一批十五萬人的送葬遊行。

一九六八年四月三日，馬丁路德金參加一場集會活動，並做題為「I've Been to the Mountaintop」演講。四月四日下午六時一分，馬丁路德金在洛林汽車旅館二樓露台被射殺身亡。此次刺殺事件導致一場全國性質的遊行與暴動浪潮，波及一百多個城市。

Photograph of the Dr Martin Luther King, Jr Memorial Procession
紀念馬丁路德金遊行攝影
1968
Ernest Withers
Silver print
24 x 16 in.

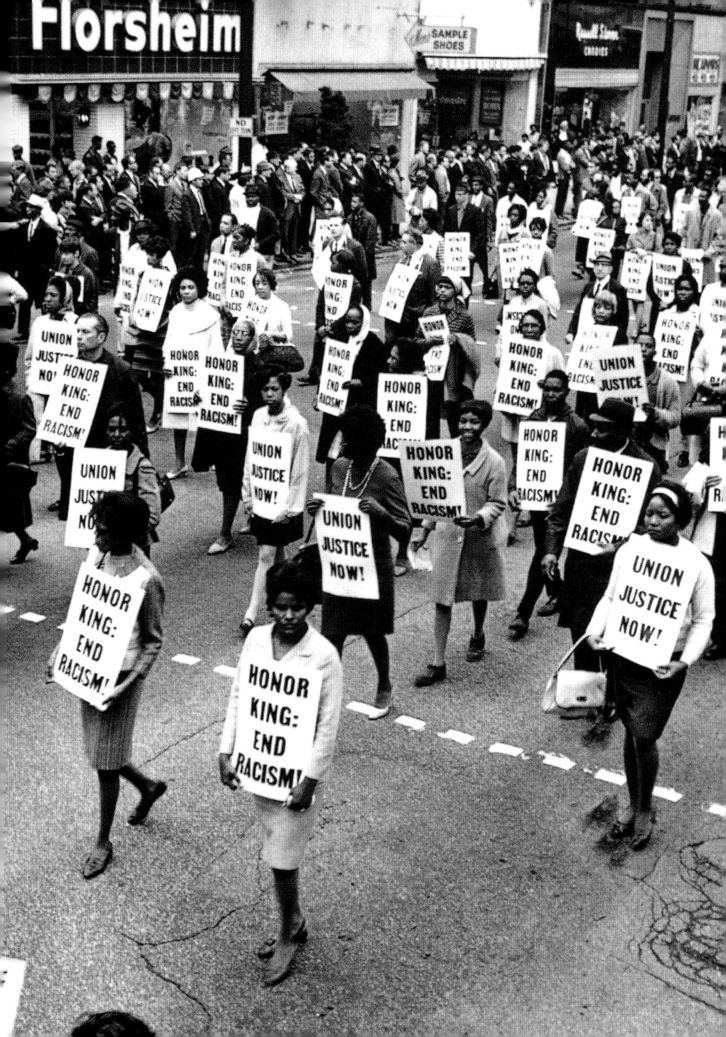

Martin Luther King, Jr.
309 South Jackson Street
Montgomery, Alabama

Minister
Dexter Avenue Baptist Church
454 Dexter Avenue

November 13, 1957

President
Montgomery Improvement
Association Inc.
530 South Union Street

Mrs. Marie Rodell
Literary Agent
15 East 48th Street
New York 17, New York

Dear Mrs. Rodell:

Enclosed is the Harper contract with my signature. I have read the contract very scrutinizingly. I have also read each of the suggestions that Pauli Murray made. I would like to ask you to urge Harpers to make the changes that Pauli Murray suggested under her points 1, 2, 3, 5, and 6. Points 4, 7, 8, 9, and 11 need not be pressed.

I will be keeping in touch with you as my writing progresses. I am still working hard to have the first draft completed by the first of December. You will be receiving some chapters from me in a few days.

Very sincerely yours,

M. L. King, Jr.

MLK:mlb

Enclosure

Letter from Rev Dr Martin Luther King, Jr to His Literary Agent
馬丁路德金牧師寫給他文學代理人的信
1957
Typed on paper
8 ½ x 11 in.

King's letterhead identifies him as Pastor of the Dexter Avenue Baptist Church and President of the Montgomery Improvement Association. Written to his literary agent, Mary Rodell, the letter refers to the contract for his first book, *Strive Toward Freedom*.

馬丁路德金在信頭將自己稱為德克斯特大街浸信會教堂牧師，以及蒙哥馬利促進協會主席。此信是寫給他的文學代理人 Mary Rodell，內容關於他首本書《Strive Toward Freedom》的合約。

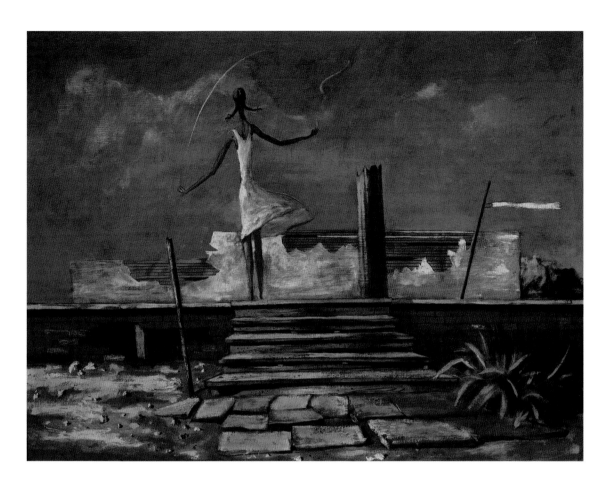

Untitled
無題
1951
Hughie Lee-Smith
Oil on masonite
18 x 24 in.

Lee-Smith attended the Cleveland Institute of Art and later earned an arts education degree from Wayne State University. In 1940, his work was exhibited at the American Negro Exposition in Chicago. Lee-Smith painted murals during his service in the Navy, and for the Works Projects Administration in Ohio and Illinois. The pointed social commentary expressed in his work limited its appeal to a wide audience, and his figurative paintings of isolated youth did not conform to the abstract expressionism dominant at the time, yet he enjoyed a position of respect within the African American arts community.

Lee-Smith 進入克里夫蘭藝術學院學習，之後在韋恩州立大學獲得藝術教育專業學位。一九四零年，他的作品被展出於芝加哥的「美國黑人博覽會」。Lee-Smith 在美國海軍服役期間，以及受俄亥俄州與伊利諾州公共事業振興署之邀，創作壁畫。他在作品中對社會的率直評論限制其作品對廣大受眾的吸引，而且他對孤立青年的具象描繪也並不符合當時主流的抽象表現主義；雖然如此，他卻依然在非洲裔美國人藝術群體中享有盛譽。

The first sit-ins by the Congress of Racial Equality in Chicago in 1943 were intended to change the attitudes of business owners—as did this one of 1960, a national boycott of Woolworth's.

From 1955–1968, acts of nonviolent protest and civil disobedience produced confrontations between activists and government authorities. Crisis situations that highlighted the inequities faced by African Americans often drew immediate attention from federal, state and local governments, and from businesses and educational institutions. Forms of protest and/or civil disobedience included boycotts, such as the successful Montgomery Bus Boycott in Alabama (1955–1956); sit-ins such as the influential Greensboro Movement in North Carolina (1960); marches, such as Selma to Montgomery in Alabama (1965); and a wide range of other nonviolent activities.

Many of those who were active in the Civil Rights Movement, in organisations such as the NAACP, SNCC, CORE and SCLC, prefer the term "Southern Freedom Movement" because the struggle was about far more than just civil rights under the law; it was also about fundamental issues of freedom, respect, dignity, and economic and social equality.

種族平等大會於一九四三年在芝加哥發起的第一次靜坐示威，力求改變企業主的態度，而此大報中的一九六零年抵制 Woolworth 活動，亦有相同訴求。

自一九五五年至一九六八年間，非暴力示威與公民抗命使得活動家與政府部門之間交鋒對抗。任何強調非洲裔美國人遭受不公待遇的危機事件，都會立即吸引聯邦、各州及地方政府，以及商業和教育機構的關注。抗議與公民抗命的形式有：聯合抵制，比如在阿拉巴馬州取得成功的「聯合抵制蒙哥馬利公車運動」（一九五五年至一九五六年）；靜坐示威，比如影響重大的北卡羅萊納州格林斯伯勒運動（一九六零年）；遊行，比如在阿拉巴馬州從塞爾瑪到蒙哥馬利的遊行（一九六五年）；以及其他多種非暴力活動。

在民權運動以及諸多組織之中，比如美國全國有色人種協進會、學生非暴力行動協調委員會、種族平等大會和南方基督教領袖協會，許多活躍人士傾向於使用「南方自由運動」一詞，因為其抗爭遠遠不止法律中的民權，更是關於自由、尊重、尊嚴，以及經濟和社會平等的基本問題。

ON'T BUY AT WOOLWORTH

NO COMPRE EN LAS TIENDAS DE WOOLWORTH

the South, students—Negro and white—are sitting in at lunch unters, quietly demanding Woolworth serve all—regardless of color.

HESE STUDENTS FACE:

ass arrests . . . Exorbitant fines . . . Expulsion threats from school . . . metimes knives, hammers, bats brandished by racist hoodlums . . .

HY DO THESE STUDENTS DO IT?

man who is robbed resists if he can. And honest men will join him since society based upon robbery is unsafe for all. What happens to one man ppens to all mankind. Segregation robs the Negro of equal economic portunity, political advancement, equal justice—and dignity as a human ing. Segregation robs America of stature before the world. Segregation forced by southern Woolworth assists in this robbery.

OOLWORTH CAN SERVE ALL!

gregated seating is NOT required by state law. Where local laws exist, ey are obviously unconstitutional. In minutes, Woolworth management n direct its Southern stores to serve everyone.

OU CAN MAKE WOOLWORTH SERVE

his Woolworth store is controlled by the national chain. Every dime ent here reinforces the chain's policy of racial segregation. DON'T ACK SOUTHERN SEGREGATION WITH YOUR MONEY!

ON'T BUY AT WOOLWORTH

OIN CORE'S PICKET LINES. Ask all other people of goodwill not to op jimcrow.

En muchos estados del Sur de los Estados Unidos, estudiantes negros y blancos se sientan en los restaurantes de las tiendas de Woolworth pacificamente y con perseverancia a esperar que les sirvan a todos sin tomar en cuenta su color o raza.

ESTOS ESTUDIANTES AFRENTAN:

Arrestos en masa, multas exorbitantes, expulsión de las universidades... En algunos casos, mientras ellos están sentados esperando que les sirvan, inescrupulosos segregacionistas les amenazan, les insultan, llegando a atacarles fisicamente.

Esta descriminación en la mayoría de los casos, está fuera de la ley; aún en los estados que estas leyes existen, estas leyes son moralmente inconstitucionales.

UD. PUEDE HACER QUE WOOLWORTH SIRVA A TODOS:

Esta tienda que hoy está siendo piqueteada y todas las demas tiendas de Woolworth están directamente conectadas con las del Sur, pues todas pertenecen a la misma cadena nacional de Woolworth.

Cada centavo o dolar que UD. gasta en estas tiendas, es un abierto ovalo a la política de la descriminación y la segregación racial que existe en el Sur.

NO APOYE LA DESCRIMINACIÓN EN EL SUR CON SU DINERO.

NO SOPORTE LA SEGREGACION COMPRANDO EN ESTAS TIENDAS QUE DESCRIMINAN CONTRA LOS GRUPOS MENORES.

Pida a todas las personas de buena voluntad que no compren en los lugares que practican la descriminación.

SOPORTE LOS DERECHOS HUMANOS!

Participe en los piquetes de CORE y propague nuestra petición.

CONGRESS OF RACIAL EQUALITY **CORE** CONGRESSO DE LA IGUALDAD RACIAL

38 Park Row, New York 38, New York

COrtlandt 7-0408

Woolworth Boycott Broadside by CORE
種族平等大會抵制 Woolworth 大報
ca. 1960
Ink on paper
8 ¼ x 10 ¾ in.
[14 ⅛ x 17 ¼ x ⅞ in. framed]

Lewis, an abstract expressionist, was elected as the first president of the Spiral Group, a legendary confederation of African American artists who wished to contribute to the Civil Rights Movement. Lewis was the only member who consistently demonstrated a commitment to anti-formalism on paper, as well as to social realism. He graduated from Columbia University but subsequently rejected formal study and began to work for the Works Projects Administration. The figurative paintings characteristic of Lewis' early work are forceful and emotional, while his later works became increasingly abstract.

Lewis 是一位抽象表現主義藝術家，當選「Spiral Group」首任主席。此團體是一個傳奇的黑人藝術家聯盟，其成員皆致力於為民權運動貢獻力量。Lewis 通常是其中唯一一位有能力在紙本上同時恪守反形式主義及社會現實主義的成員。他畢業於哥倫比亞大學，但並未繼續深造，而是開始為公共事業振興署工作。Lewis 的早期創作以具象畫為典型，具有很強的衝擊力與豐富的情感，而之後的作品則愈發抽象。

Untitled ("To Rosalie and Robert
[Gwathmey] for Great Summers")
無題（「致 Rosalie Gwathmey 和
Robert Gwathmey 的盛夏」）
1977
Norman Lewis
Oil on paper
38 x 31 ¾ in.

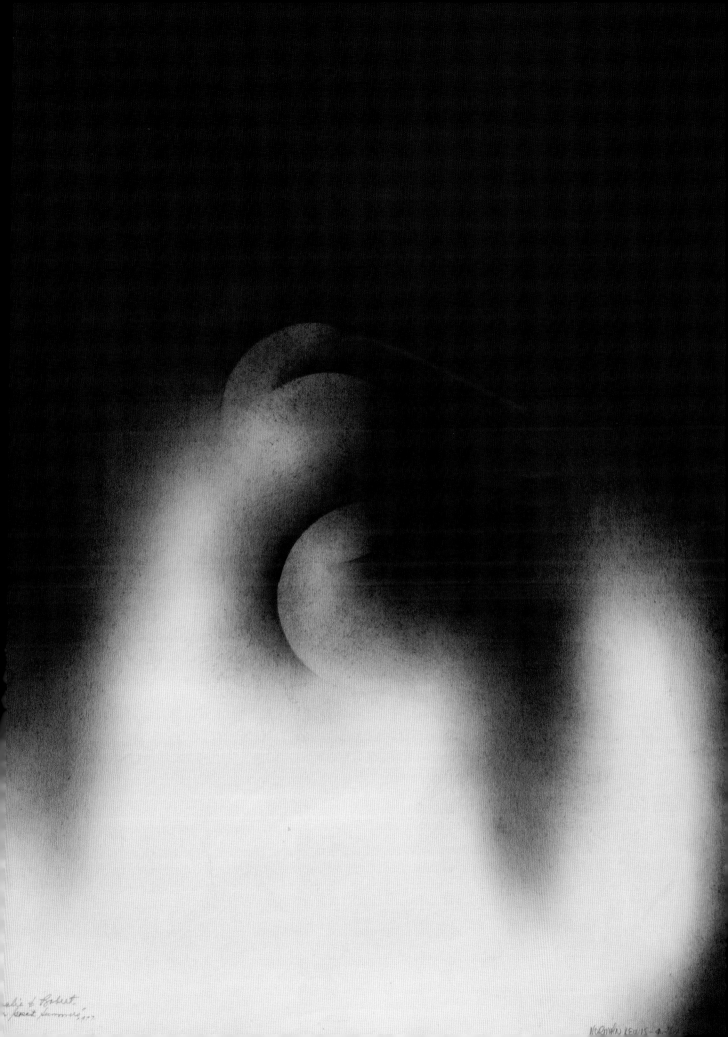

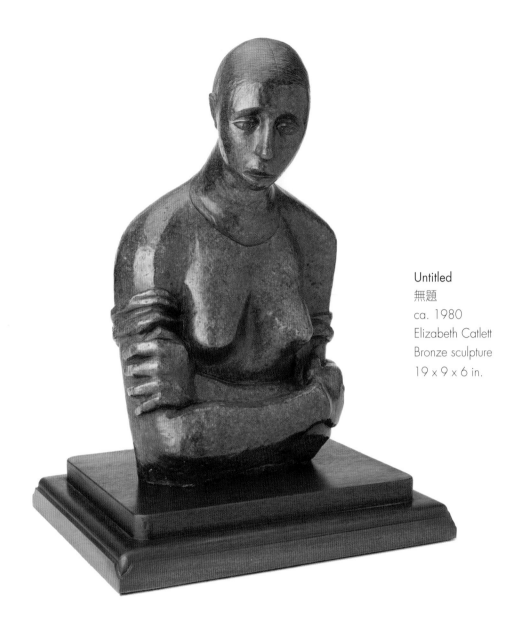

Untitled
無題
ca. 1980
Elizabeth Catlett
Bronze sculpture
19 x 9 x 6 in.

Catlett (1915–2012), who studied with Lois Mailou Jones at Howard University, fell in love with sculpture and the work of Mexican muralists under the tutelage of James Porter. Later, she earned the first master's degree awarded in fine arts at the University of Iowa. Catlett won a Rosenwald Fund fellowship in 1946 and traveled to Mexico where Diego Rivera, Rufino Tamayo and Francisco Mora, whom she later married, befriended her; she lived in Mexico for the rest of her life. Her renown as a sculptor and printmaker developed steadily over her long career.

Catlett（一九一五年至二零一二年），在侯活大學師從 Lois Mailou Jones，並在 James Porter 的指導下鐘情於雕塑創作和墨西哥壁畫家的作品。之後，她在愛荷華大學美術專業獲得第一個碩士學位。Catlett一九四六年榮獲「Rosenwald獎學金」，並前往墨西哥，結識迪亞高·里維拉（Diego Rivera）、羅勳奴·塔馬約（Rufino Tamayo）和弗朗西斯科·莫拉（Francisco Mora，亦即她之後的丈夫），之後一直生活於墨西哥。她作為雕塑家與版畫家的聲望在其漫長的職業生涯中穩步提高。

Schooled by Charles Alston and other Harlem Renaissance notables, Lawrence received his early education in Harlem. Growing up, he observed the daily life of African Americans and these scenes comprise much of Lawrence's subject matter. His series on the Great Migration, which combines stylistic interpretation with a historically grounded perspective on black life, was acquired by the Metropolitan Museum of Art in New York, making Lawrence the first African American artist represented in that institution's permanent collection.

Lawrence 在紐約哈林區接受早期教育,師從 Charles Alston 及其他「哈林文藝復興」名家。他在成長中不斷觀察非洲裔美國人的日常生活,而這些場景亦構成其創作的主要題材。他的「大遷徙」系列,結合對黑人生活的風格化解讀與歷史視角,現被收藏於紐約大都會藝術博物館之中,而這也使 Lawrence 成為該博物館永久館藏中的第一位非洲裔美國人藝術家。

John Brown Series, #8
約翰·布朗系列之八
1977
Jacob Lawrence
Serigraph
22 ½ x 28 ¼ in.

Thomas was the first graduate of the Howard University art department and the first black woman to earn an MFA from Columbia University. After teaching in the Washington, D.C. public schools for 35 years, she began her professional career. She was among the colour-field painters active in D.C., and in 1943, she was asked by James Vernon Herring and Alonzo Aden to join them in establishing the Barnett-Aden Gallery, the first African American gallery in that city. In 1971, when she was 80 years old, she became the first female African American artist to be recognised in a solo exhibition at the Whitney Museum of American Art.

Thomas 是侯活大學藝術系的首批畢業生，也是哥倫比亞大學榮獲藝術碩士的第一位黑人女性。在華盛頓特區公立學校任教三十五年之後，她開始其職業創作生涯。她是活躍於華盛頓特區的色域畫家之一。一九四三年，她受 James Vernon Herring 與 Alonzo Aden 之邀，助其建立「Barnett-Aden Gallery」，即城中第一間非洲裔美國人藝術館。一九七一年，她年屆八十之際，成為在惠特尼美國藝術博物館中舉辦個展的第一位非洲裔美國女性。

Untitled
無題
1970
Alma Thomas
Acrylic on paper
22 x 18 in.

Samuel Dunson depicts three African Americans harvesting books from the soil of the earth. A woman wipes the dirt off a volume while a young man behind her holds a copy of *The Prophet* by Kahlil Gibran. While the male has cultivated a bag full of books, his clothing suggests that this work is not menial labor. These individuals are cultivating knowledge. Bernard, Shirley and their son Khalil are the subjects in Samuel Dunson's portrait.

Samuel Dunson 在畫中描繪了三位非洲裔美國人播種者，他們正從土地中收穫書籍。畫中的女人正為一本書擦拭塵土，而她身後的年輕男人則手捧紀伯倫（Kahlil Gibran）的《先知》一書。畫面近景處的這位男性已經收穫滿滿一袋書籍，但是他的衣著卻顯示，這種收穫並非低微的體力勞動。他們三人在收穫知識。Samuel Dunson 的繪畫人物是Bernard、Shirley 及其子 Khalil。

The Cultivators
播種者
2000
Samuel L. Dunson, Jr.
Oil on canvas
38 ½ x 26 ½ in.

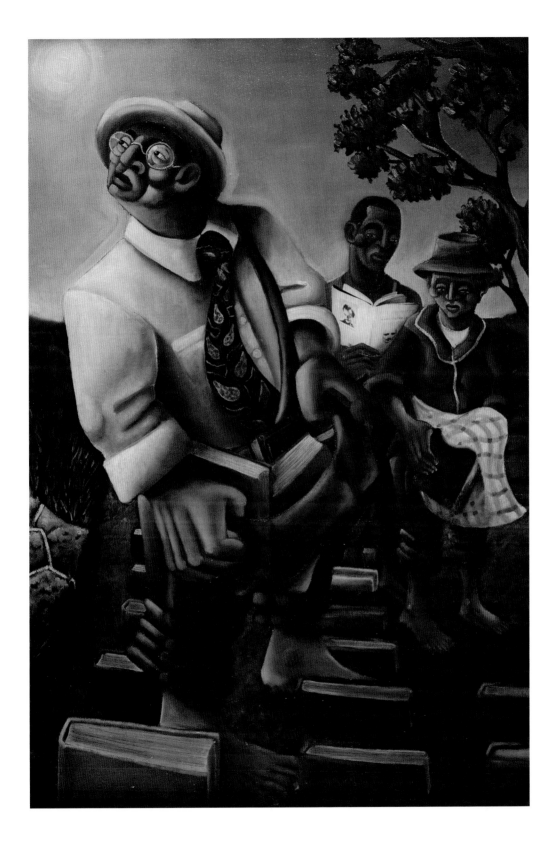

Dwight's first major commission was to create a sculpture of George Brown, Colorado's first black Lt. Governor. For the Colorado Centennial Commission, Dwight was asked to produce 30 bronzes depicting the contributions of African Americans to the expansion of the West. In the series *Jazz: An American Art Form*, Dwight explored the musical contributions of jazz to the fabric of American life and culture. Dwight has been involved with many public art projects, including monuments in Detroit and in Windsor, Canada, dedicated to the Underground Railroad. His largest memorial work, honouring Martin Luther King, Jr, is installed in Denver.

Dwight 首次主要工作邀約，即是為哥羅拉度州首位黑人副州長 George Brown 製作雕塑。在哥羅拉度州百年紀念項目中，Dwight 創作了三十件青銅作品，以展示非洲裔美國人在西進運動中的貢獻。Dwight 在其「爵士樂：一種美國藝術形式」系列作品中，探索爵士樂在美國生活及文化中的作用。Dwight 曾參加眾多公眾藝術項目，包括在美國底特律與加拿大溫莎為紀念「地下鐵路」而製作的紀念碑。他最大型的紀念作品，當屬置於丹佛的馬丁路德金紀念碑。

Old Maasai Woman
馬賽族老婦
1986
Ed Dwight
Bronze
38 x 14 x 10½ in.

An educator and painter, Pratt grew up in Washington, D.C. He studied with sculptor and painter Phillip Ratner and went on to the Hampton Institute in Virginia, later studying in France. Pratt worked for the prestigious Barnett-Aden Collection. In 1989, one of his paintings was featured on the cover of *Art Now* magazine. His work is held in many corporate and private collections in the United States and Europe.

Pratt 是一位成長於華盛頓特區的教育家與畫家。他師從雕塑家及畫家 Phillip Ratner，之後進入維吉尼亞的漢普頓學院，又前往法國學習。Pratt 為享負盛名的「Barnett-Aden Collection」工作。一九八九年，他的一幅作品登上《Art Now》雜誌封面。他的作品被美國和歐洲的眾多團體與私人收藏。

Étude 17 en Couleur
2002
Ed Pratt
Oil on canvas
24 x 18 in.

Mayhew studied at the Art Students League and Hans Hofmann's School of Fine Art in New York. Under Hofmann, he pursued abstract expressionism and joined it to his spiritual appreciation of nature in order to create improvisational landscapes. Mayhew also earned an art history degree from Columbia University. He was a founder of the Spiral Group, which addressed political and aesthetic issues related to what Ralph Ellison called a "a new visual order." His work is in the permanent collections of the Smithsonian, the Whitney Museum of American Art and the Brooklyn Museum of Art.

Mayhew 受教於紐約藝術學生聯盟以及 Hans Hofmann 創建的美術學校。在後者學習期間,他開始追求抽象表現主義,並將之融入靈魂中的自然意趣,以創作即興風景畫。Mayhew 亦於哥倫比亞大學獲得藝術史專業學位。他是「Spiral Group」的創建者之一,該團體致力於探討政治,以及關乎拉爾夫·艾里森(Ralph Ellison)所謂「新視覺秩序」的審美意趣。他的部分作品被史密森尼學會、惠特尼美國藝術博物館以及布魯克林博物館永久收藏。

Fugue
賦格
2000
Richard Mayhew
Oil on canvas
55 ½ x 51 ½ in.

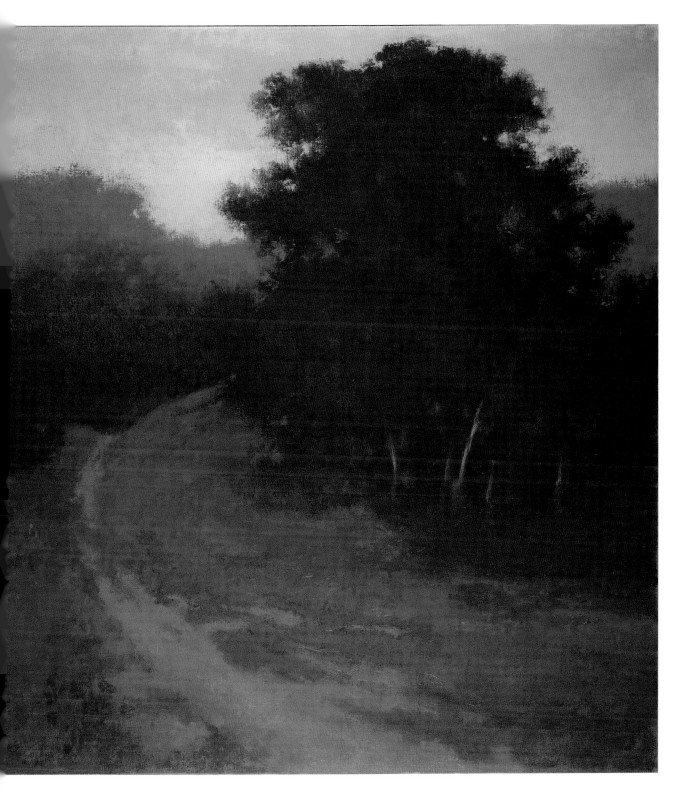